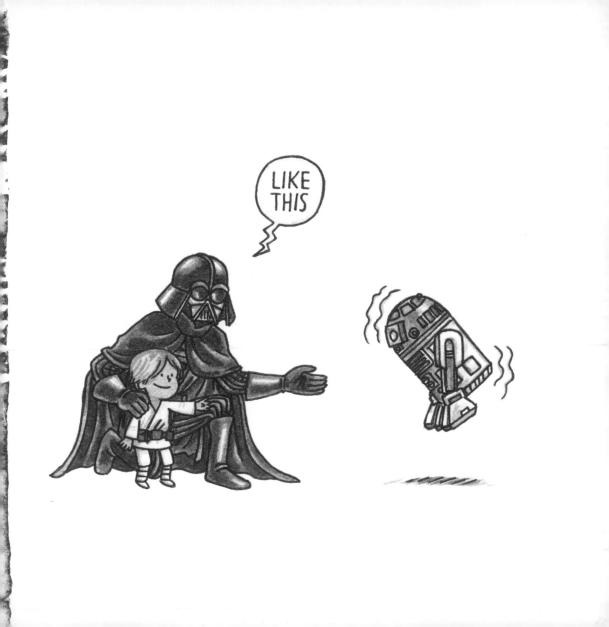

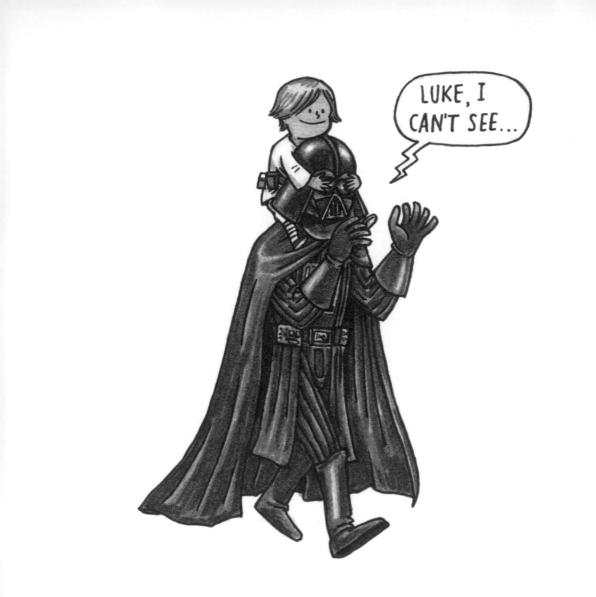

JEFFREY BROWN

CHRONICLE BOOKS SAN FRANCISCO

60

COPYRIGHT @2012 BY LUCASFILM LTD & B . TM WHERE INDICATED.

ALL RIGHTS RESERVED. USED UNDER AUTHORIZATION. NO PART OF THIS BOOK MAY BE REPRODUCED IN ANY FORM WITHOUT WRITTEN PERMISSION FROM THE PUBLISHER.

LIBRARY OF CONGRESS CATALOGING-IN-PUBLICATION DATA:

BROWN, JEFFREY, 1975-

DARTH VADER AND SON/BY JEFFREY BROWN.

ISBN 978-1-4521-0655-7

1. STAR WARS-COMIC BOOKS, STRIPS, ETC. 2. VADER, DARTH (FICTITIOUS CHARACTER)-COMIC BOOKS, STRIPS, ETC. 3. FATHERS AND SONS-COMIC BOOKS, STRIPS, ETC. 4. AMERICAN WIT AND HUMOR 5. GRAPHIC NOVELS, I. TITLE.

PNG727. B7575D 372011 741.5'973--Dc23

2011038954

MANUFACTURED IN CHINA

WRITTEN AND DRAWN BY JEFFREY BROWN DESIGNED BY MICHAEL MORRIS

THANKS TO STEVE MOCKUS, J.W. RINZLER, MARC GERALD, AND MY FAMILY. SPECIAL THANKS TO RYAN GERMICK AND MICHEAL LOPEZ AT GOOGLE, WHO LET ME RUN WITH THEIR ORIGINAL IDEA OF LUKE AND DARTH VADER AWKWARDLY CELEBRATING FATHER'S DAY.

31 30 29 28 27 26

CHRONICLE BOOKS LLC 680 SECOND STREET SAN FRANCISCO, CA 94107 WWW. CHRONICLEBOOKS. COM

WWW.STAR WARS.COM

© & TM 2015 LUCASFILM LTD.

A long time ago in a galaxy far, <u>far away....</u>

Episode Three and a half. DARTH VADER AND SON Darth Vader, Dark Lord of the Sith, leads the Galactic . Empire against the heroic Rebel Alliance. Béfore he can take care of the Rebels, Lord Vader must first take care of his sonfour-year-old Luke Skywalker....

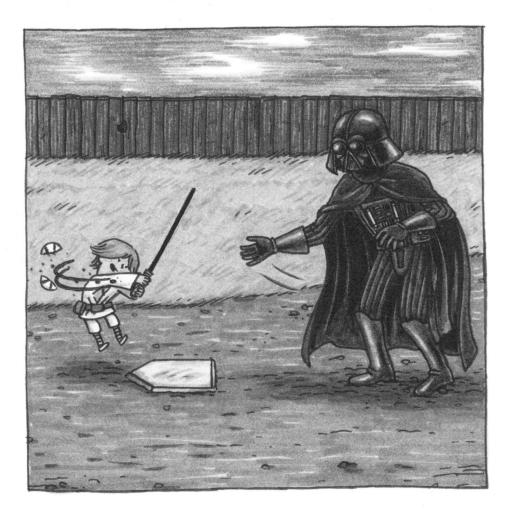

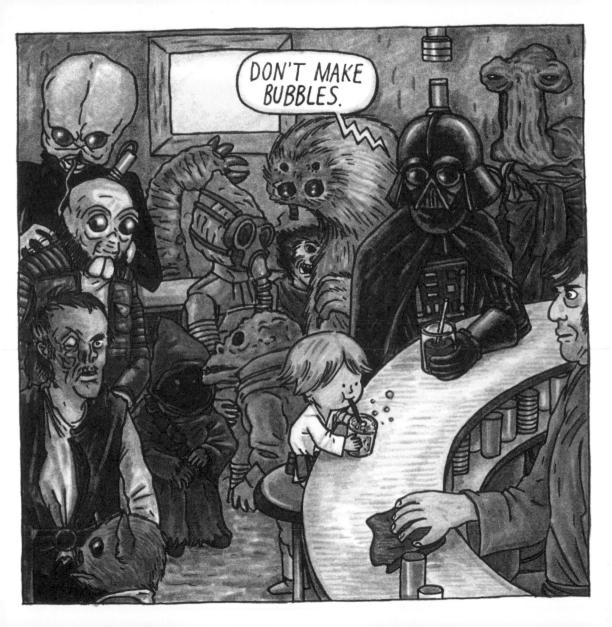

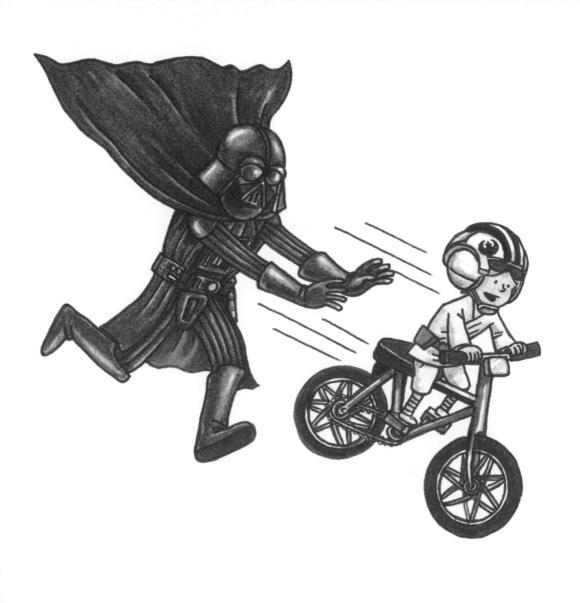

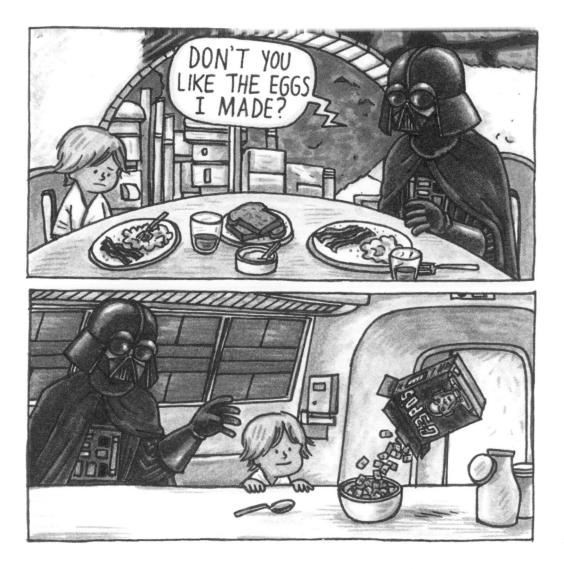

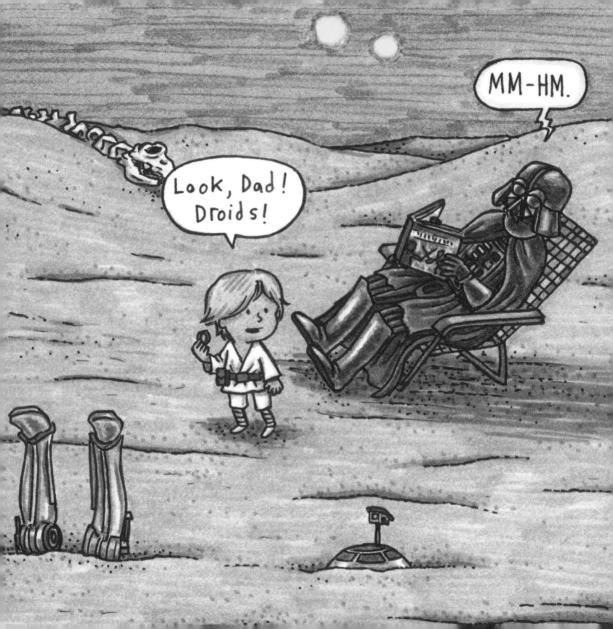

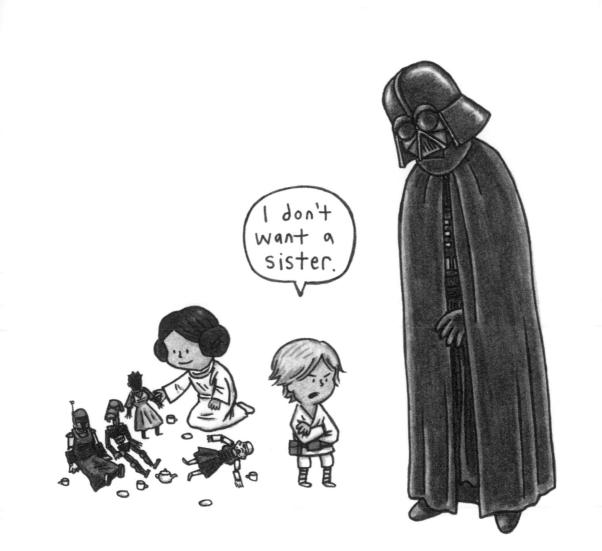

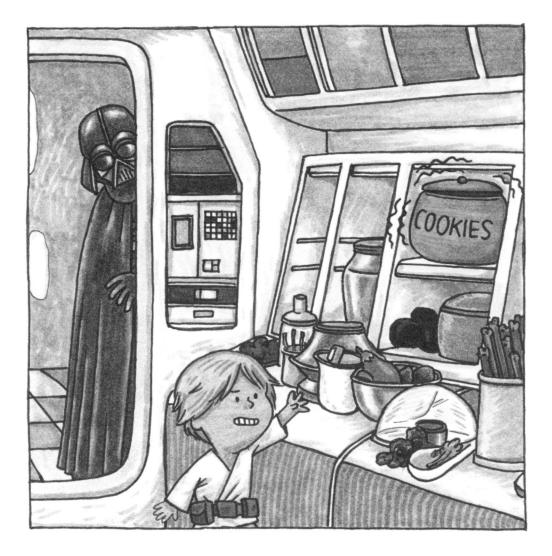

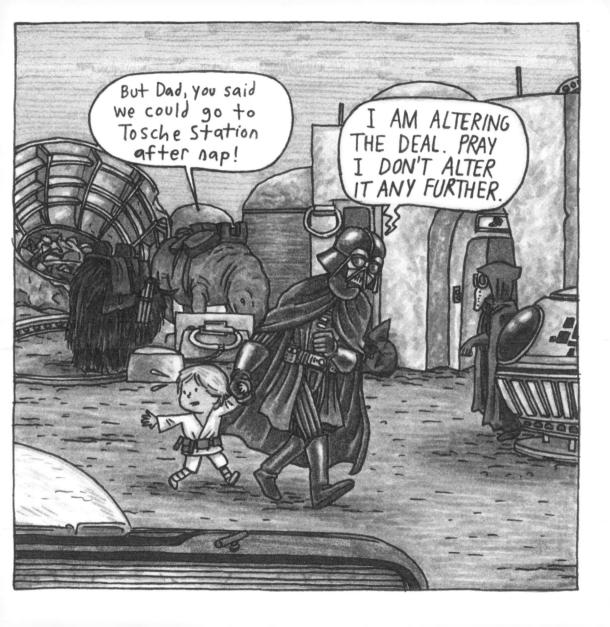

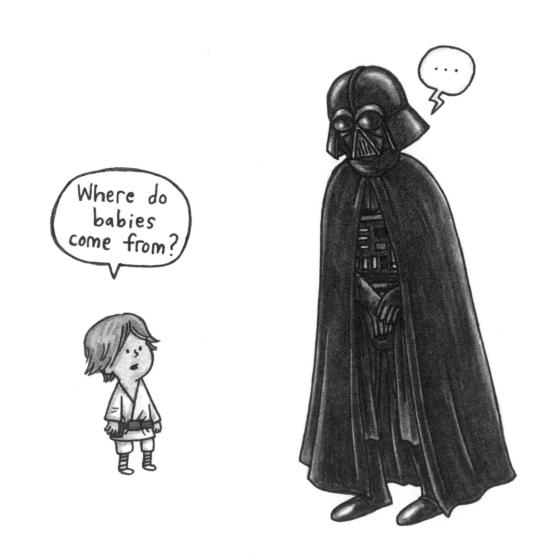

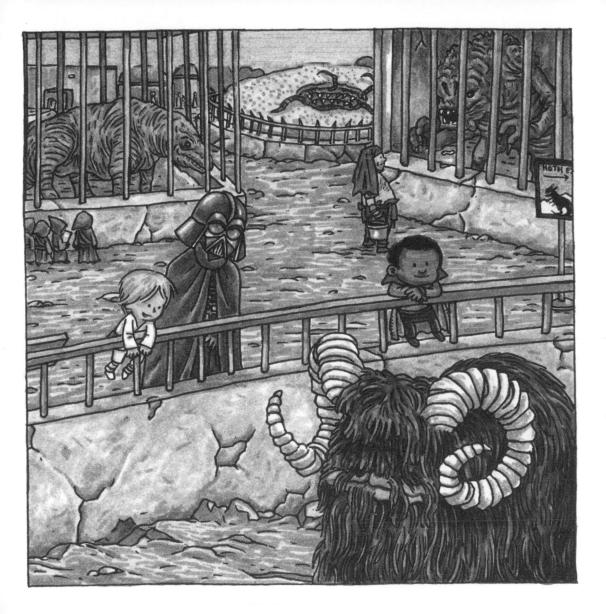

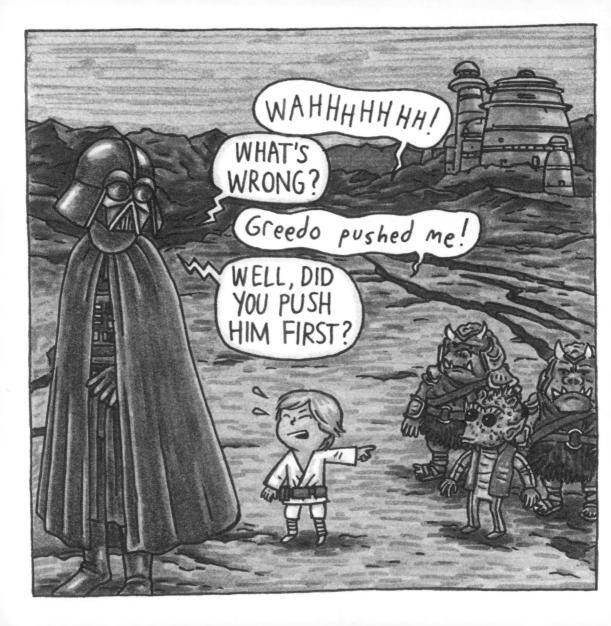

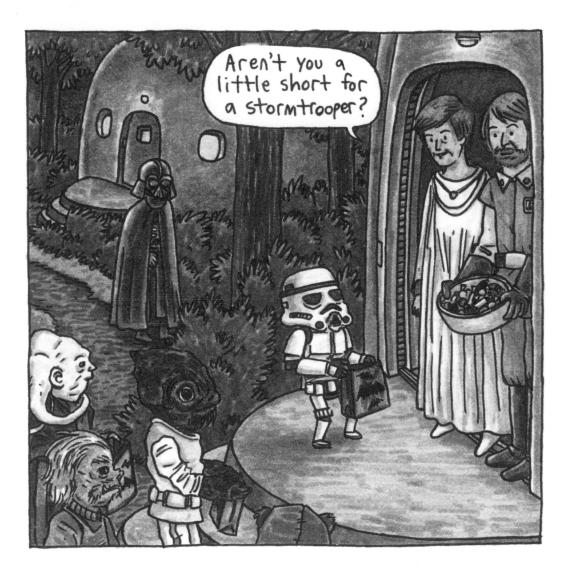

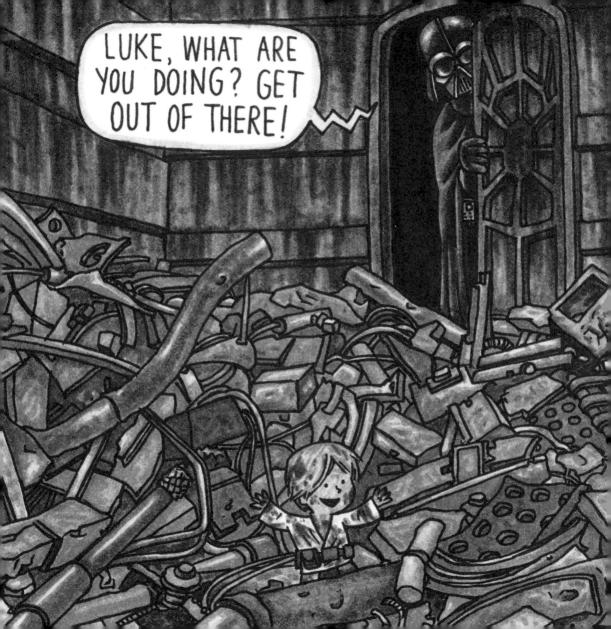

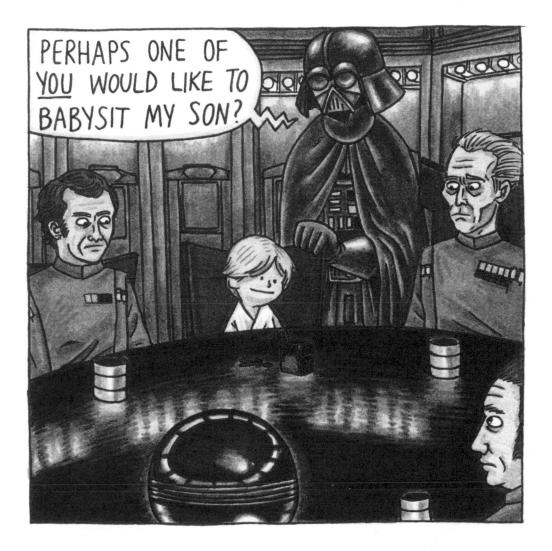

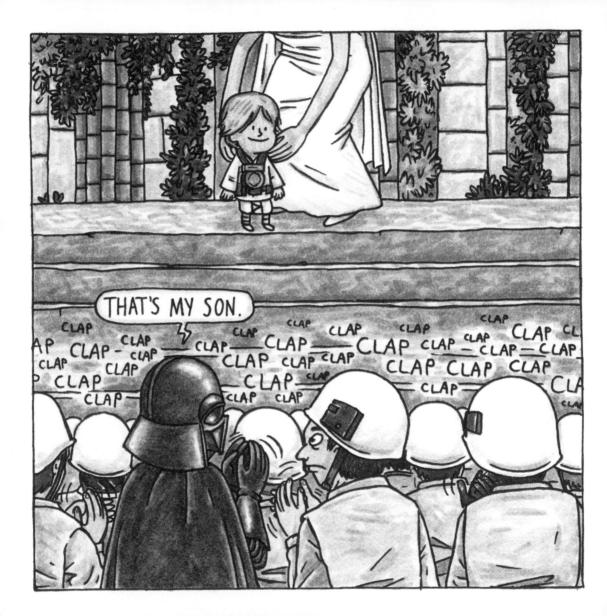

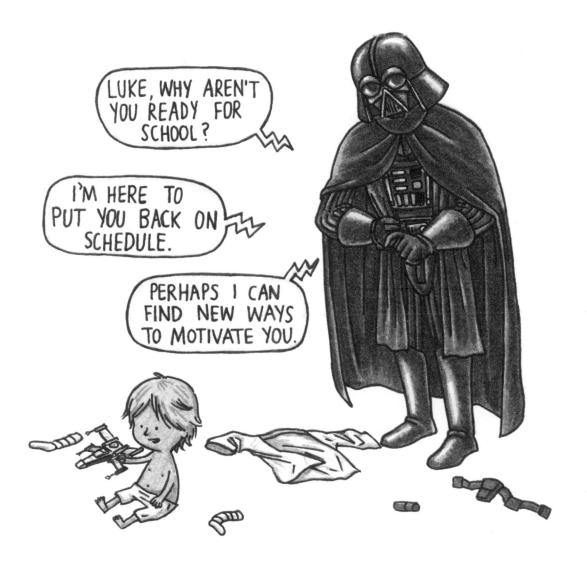

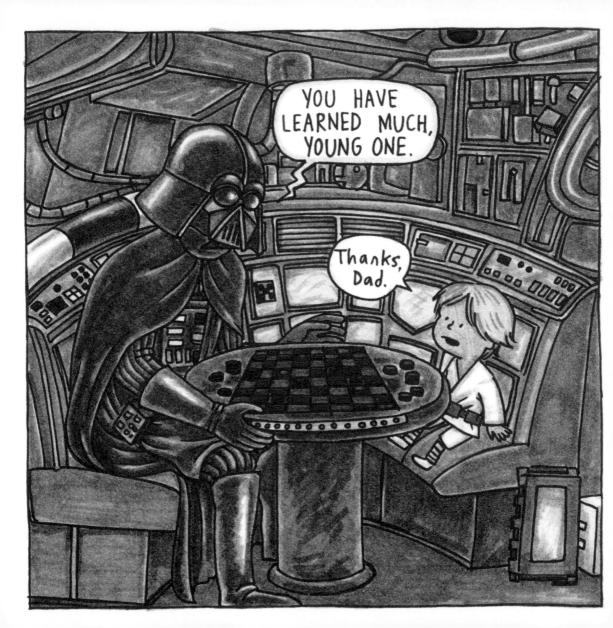

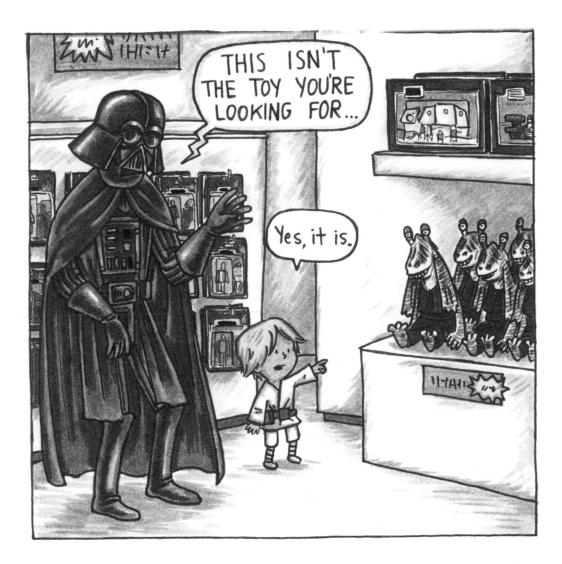

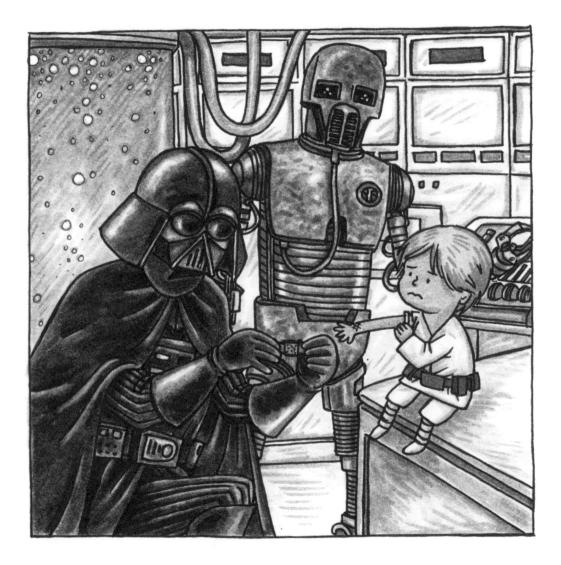

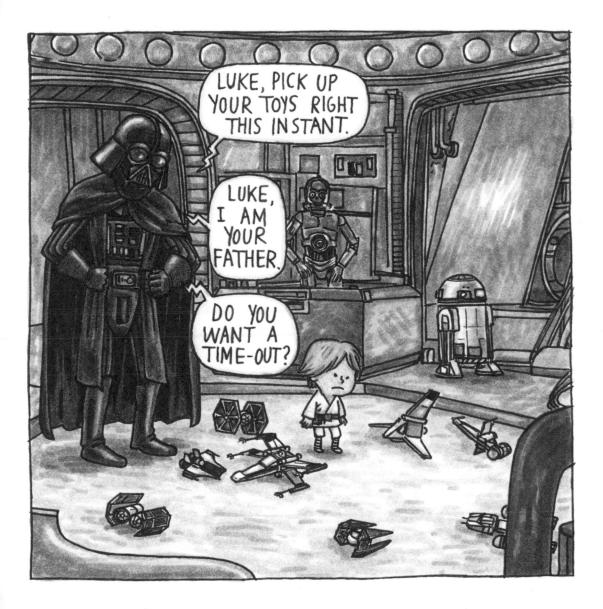

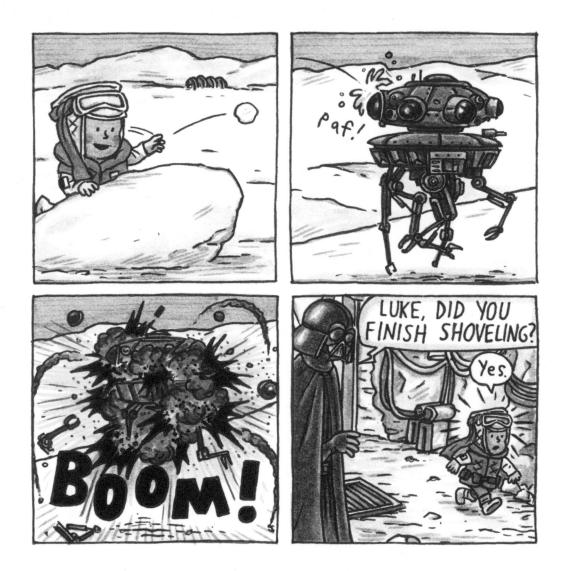

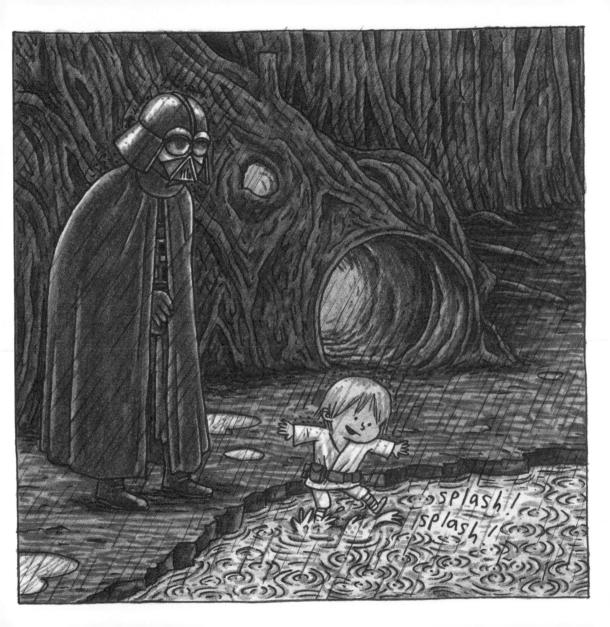

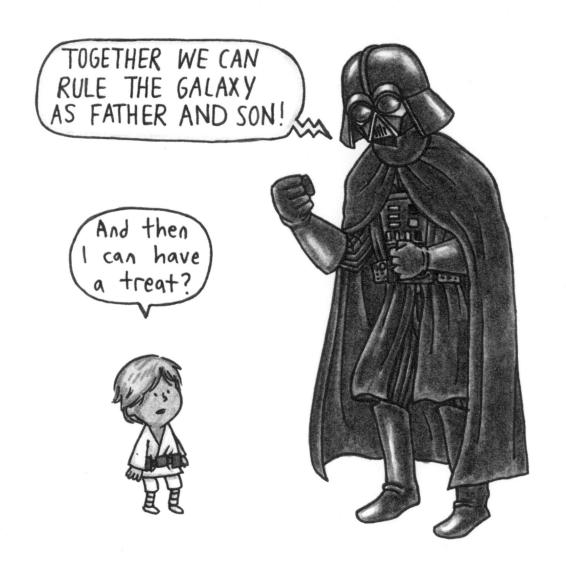

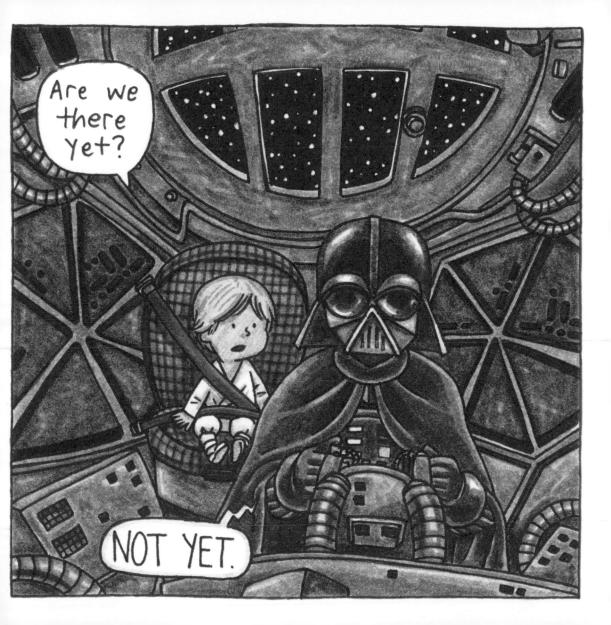

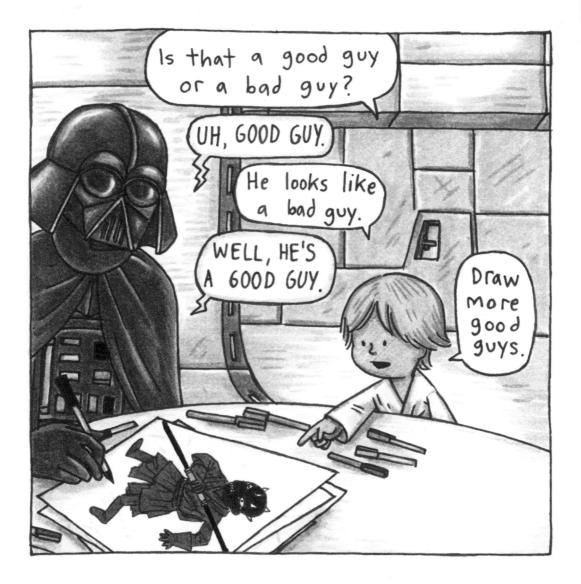

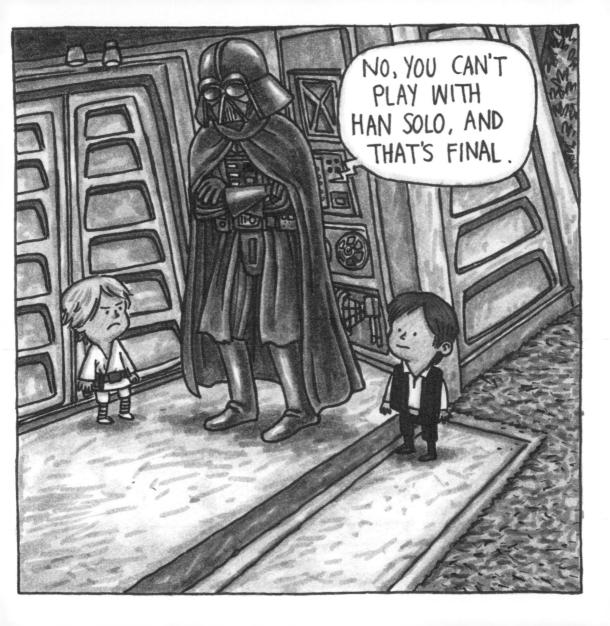

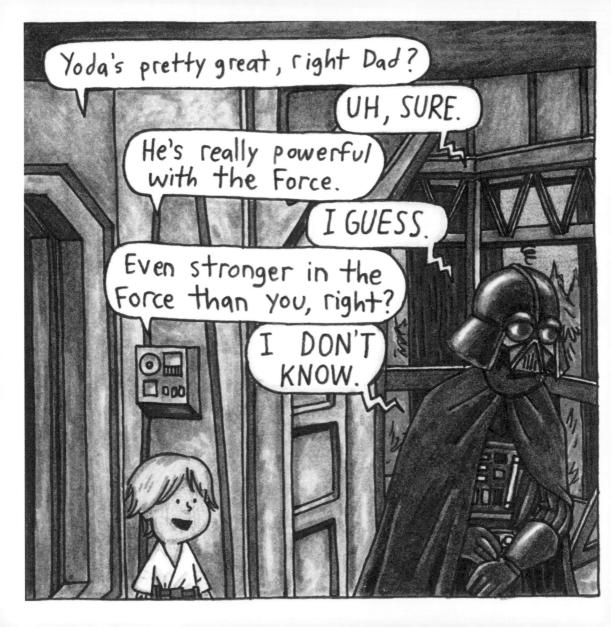

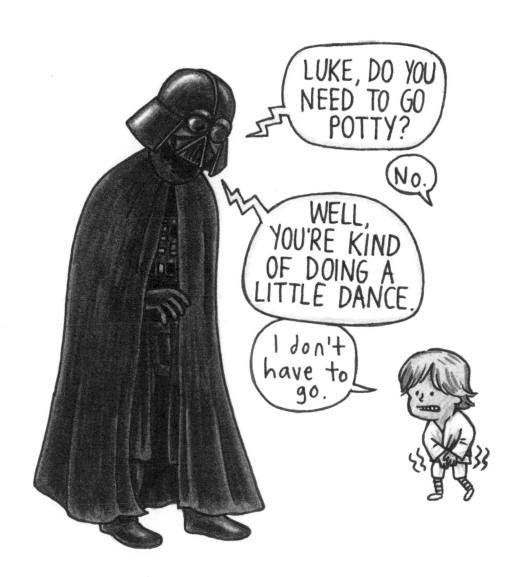

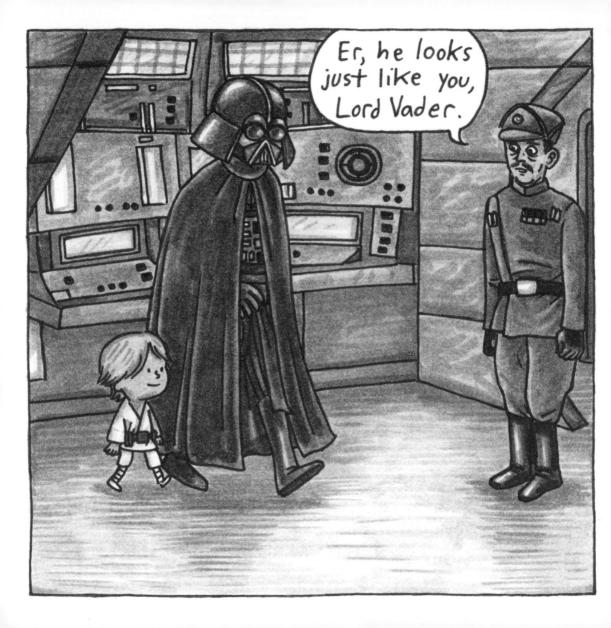

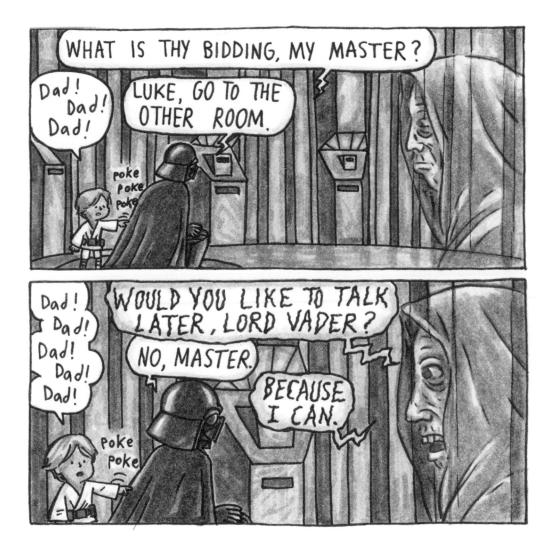

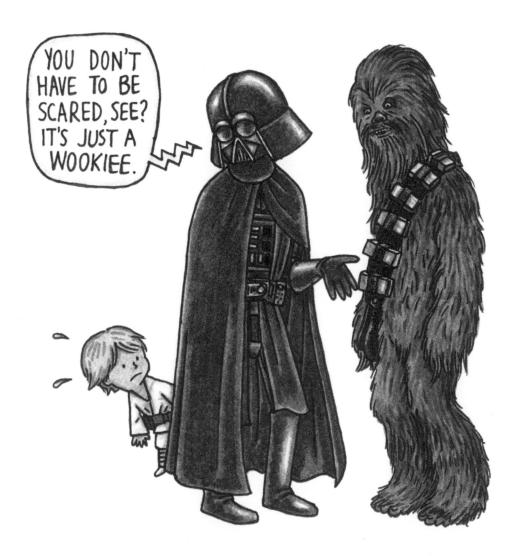

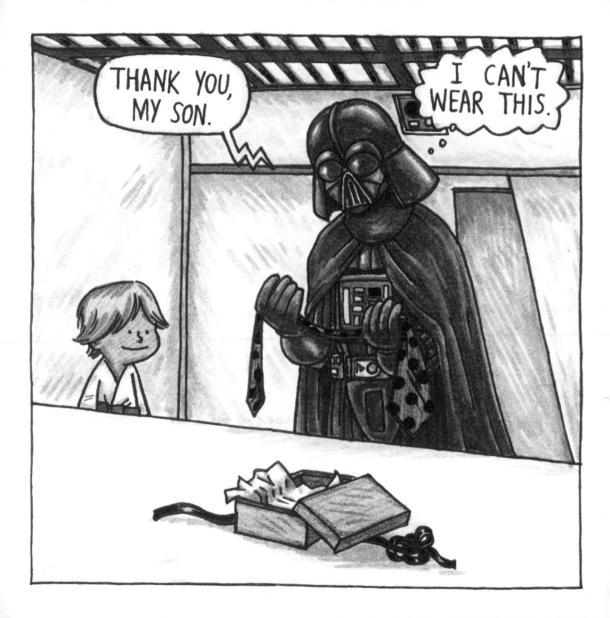

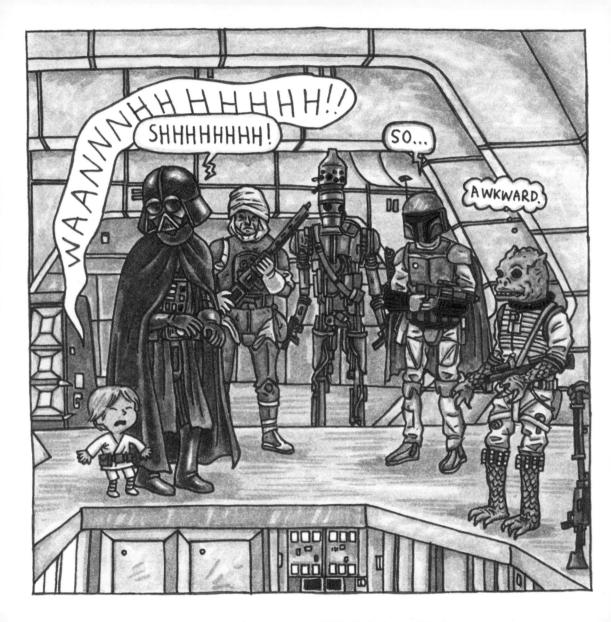

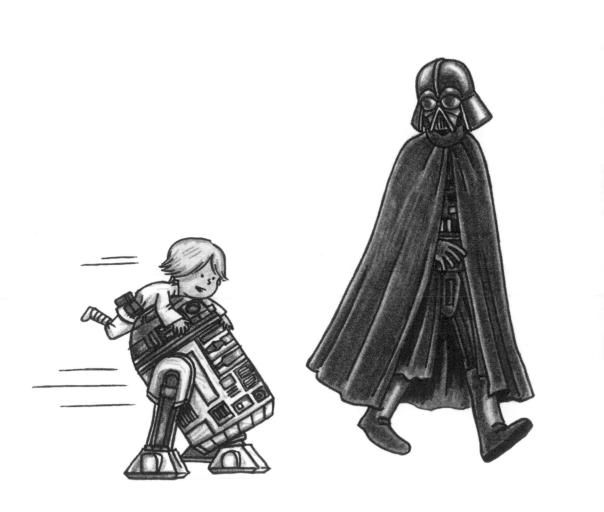

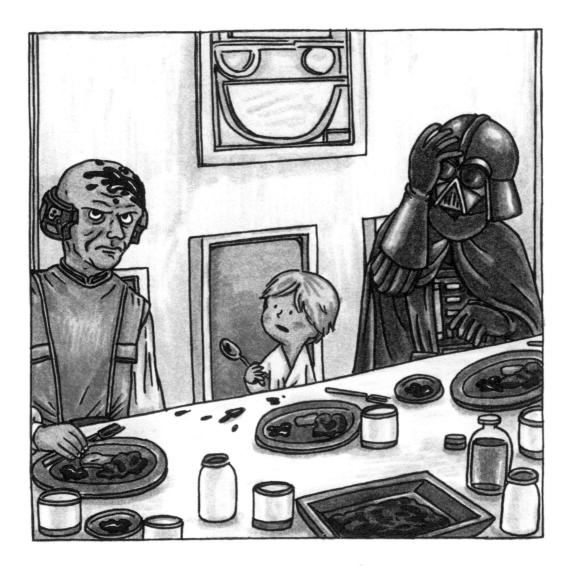

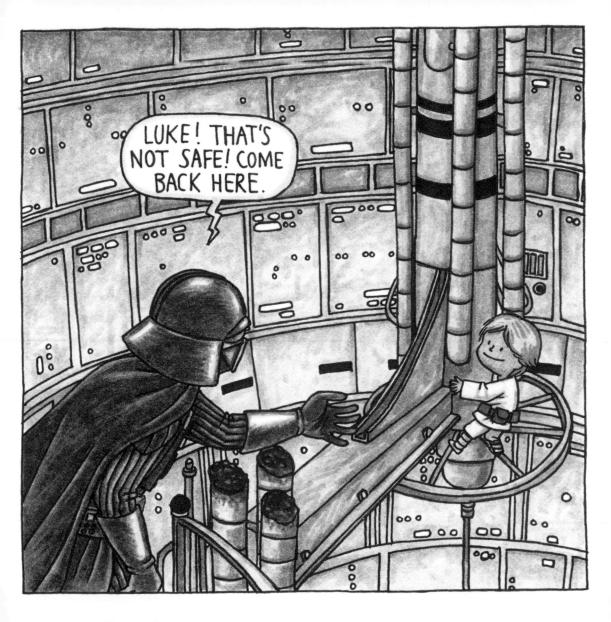

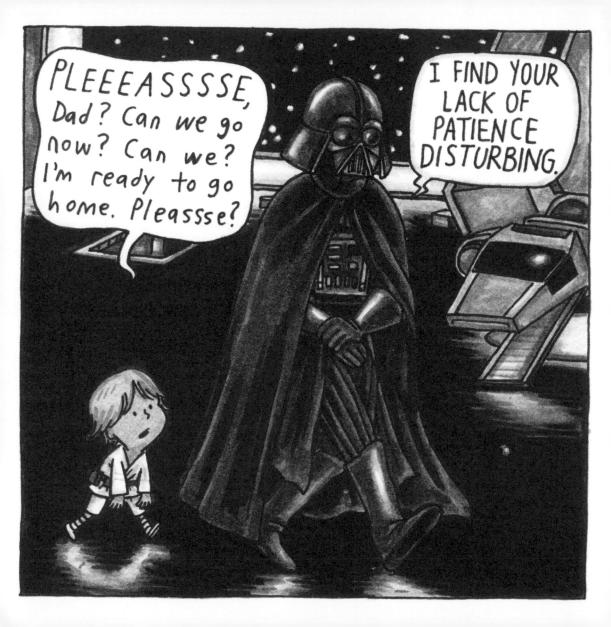

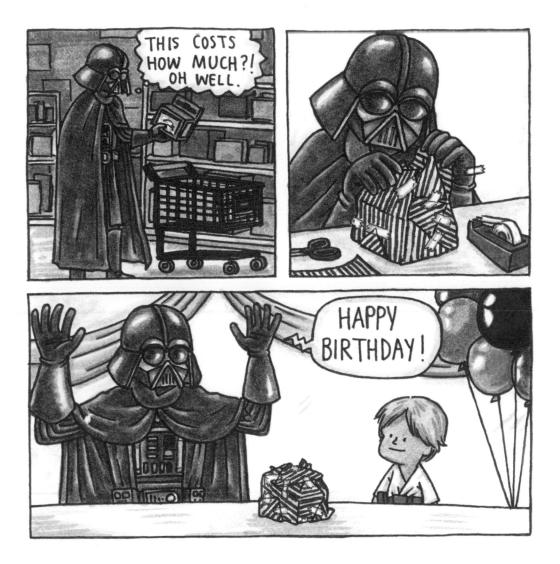

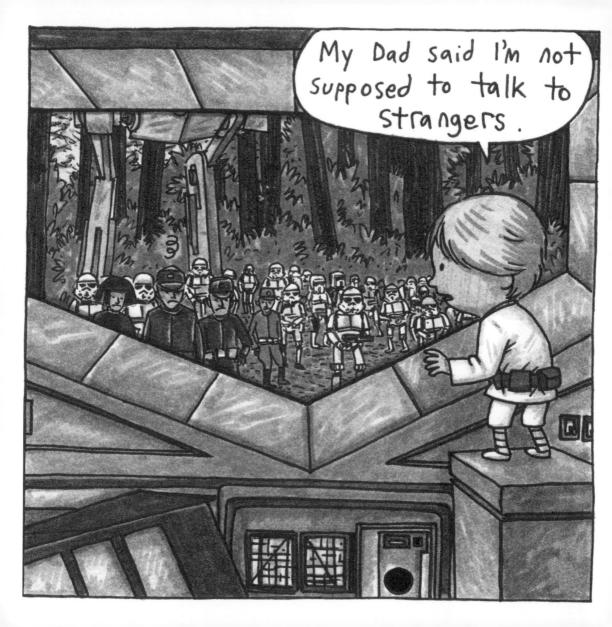

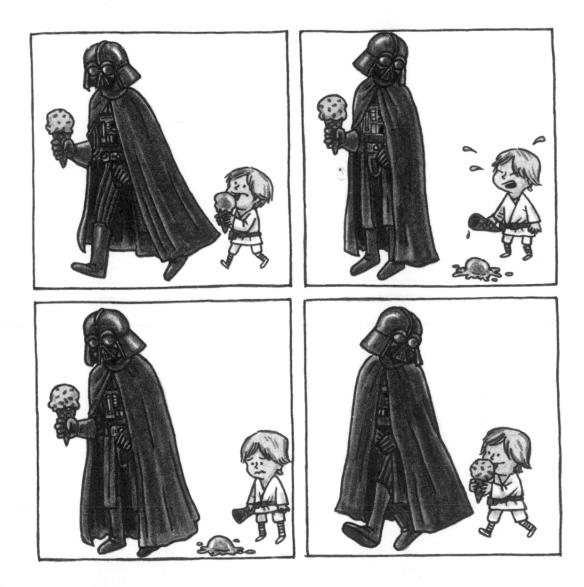

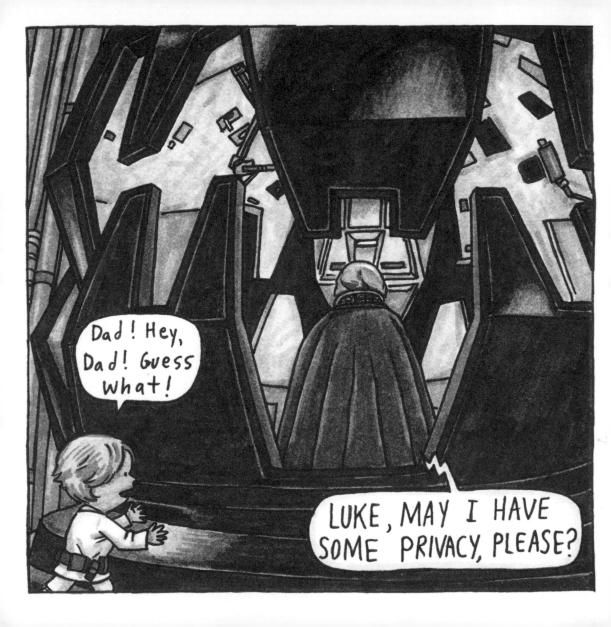

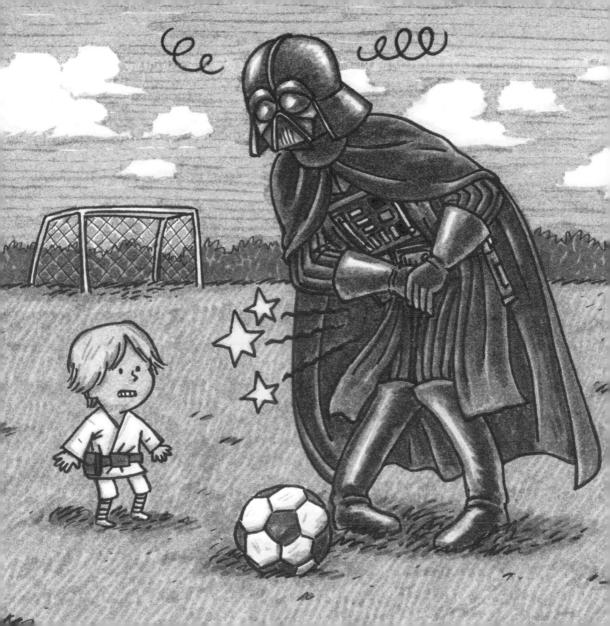

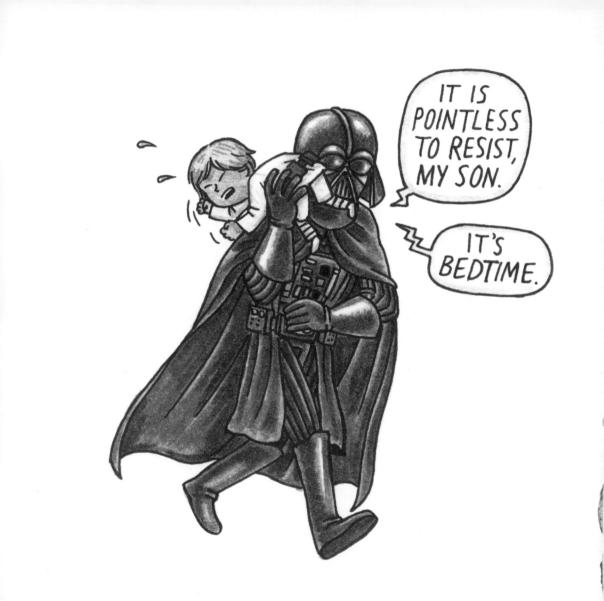

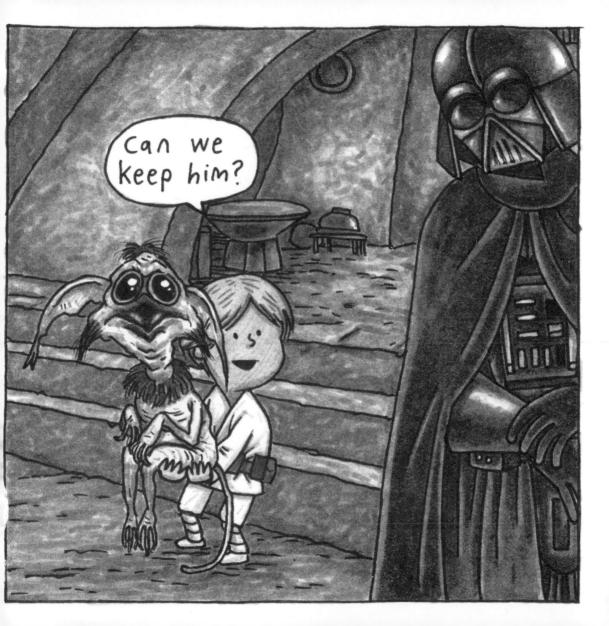

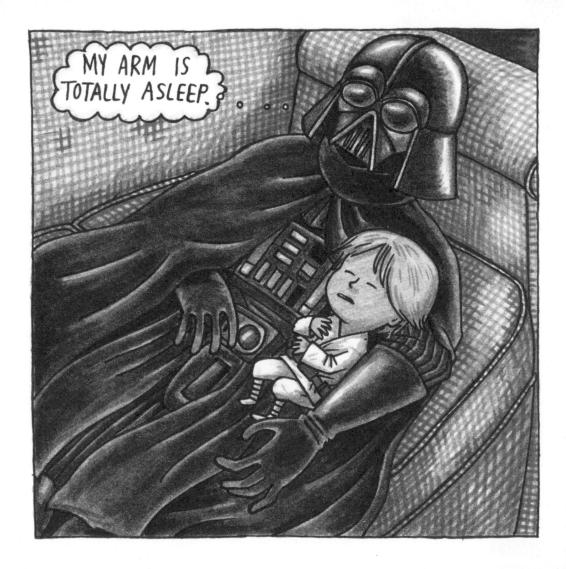

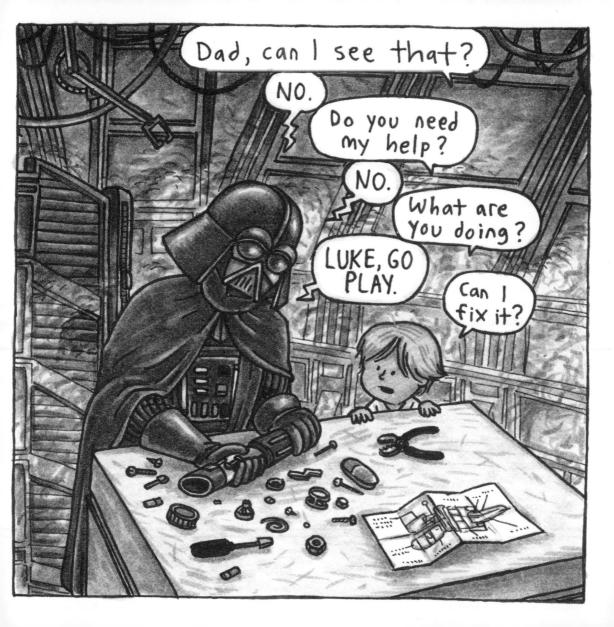

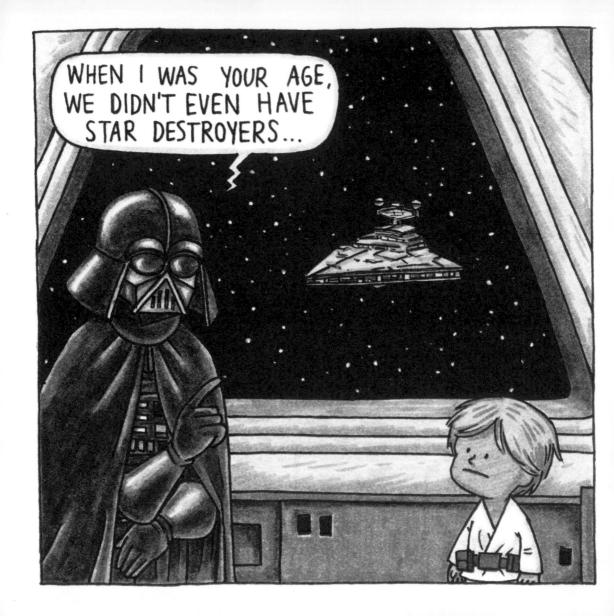

LUKE, COME WITH ME. Why? BECAUSE IT IS THE ONLY WAY. Why? BECAUSE. Because why?

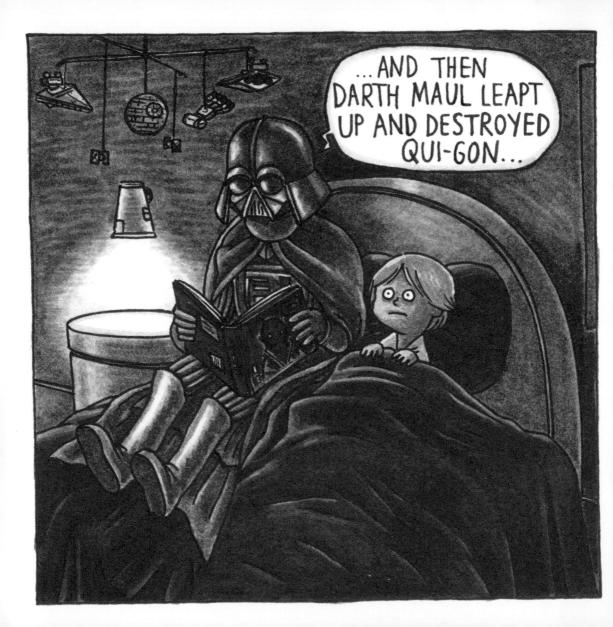

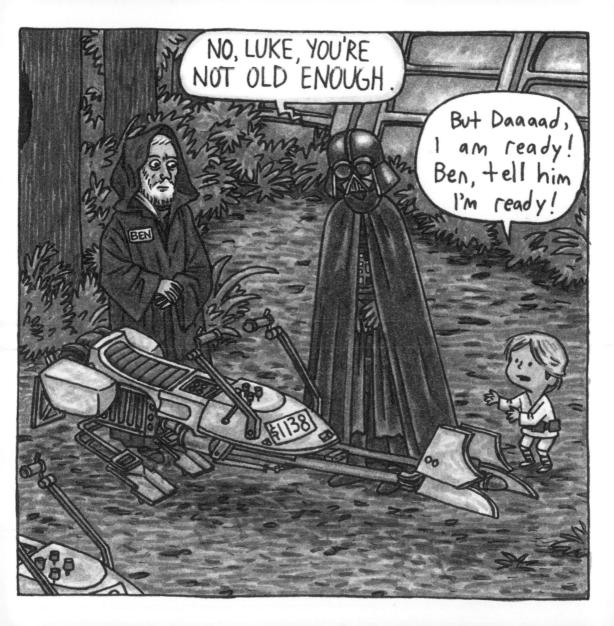

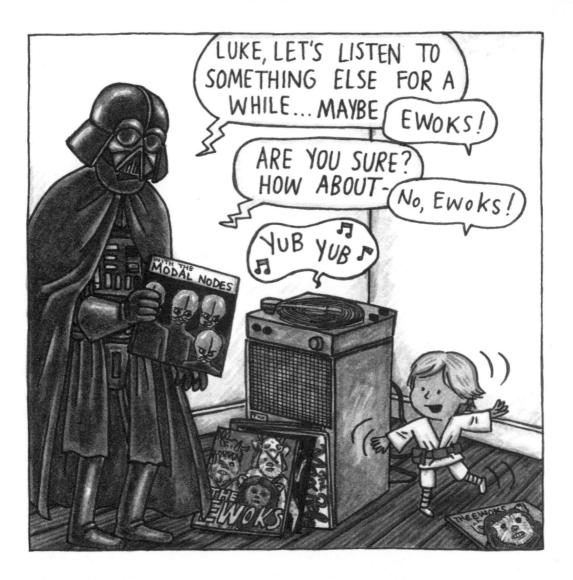

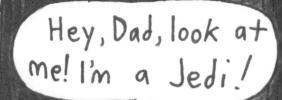

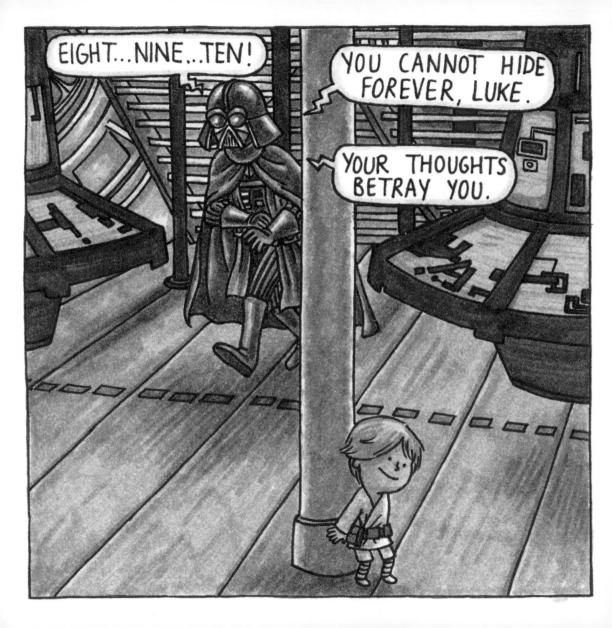

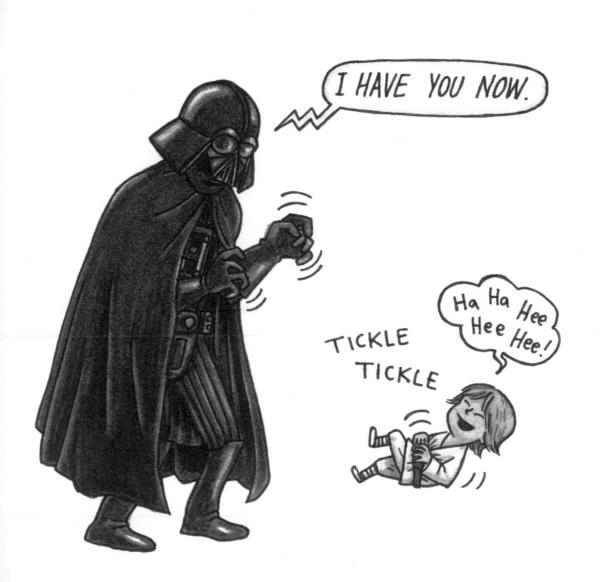

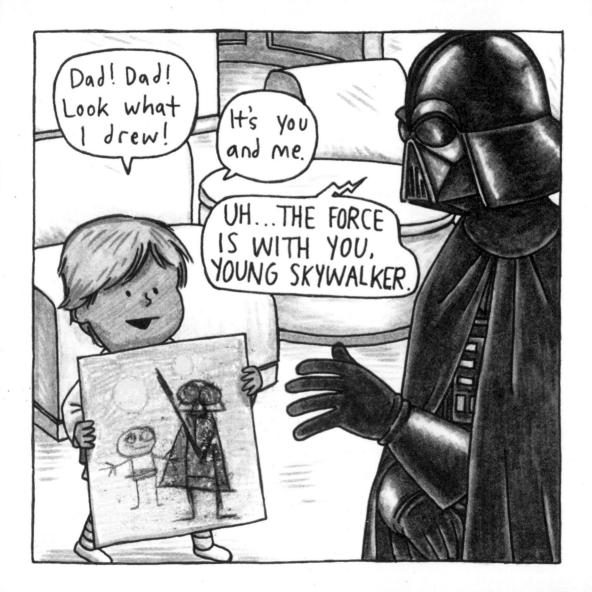

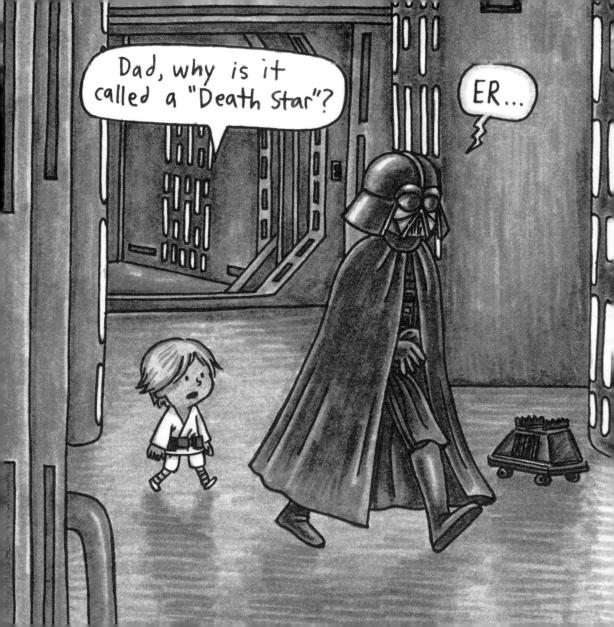

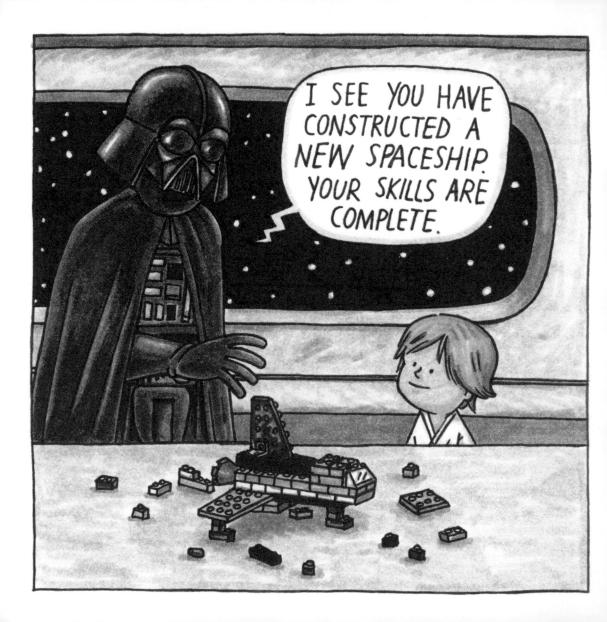

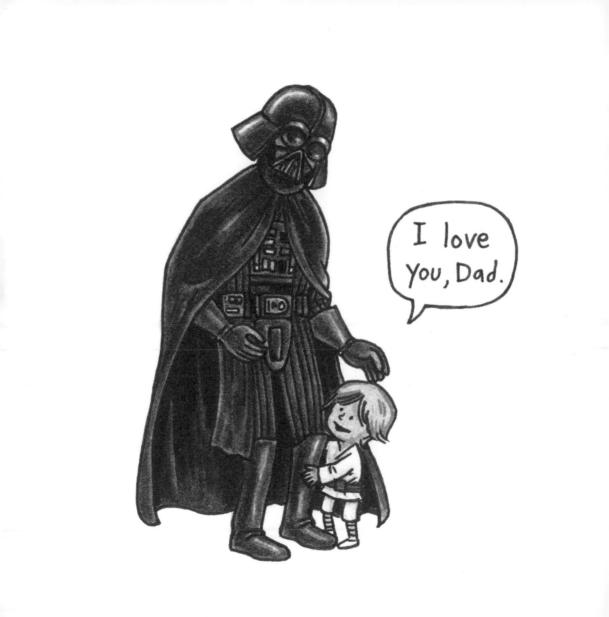

Jeffrey Brown is best known for his autobiographical comics and humorous graphic novels. He grew up watching Star Wars, Playing with Star Wars action figures, and collecting Star Wars trading cards. He lives in Chicago with his wife, Jennifer, and sons,

WWW. JEFFREY BROWNCOMICS. COM P.O. BOX 120 DEERFIELD IL GOOIS-0120 USA

Oscar and Simon.

MORE BOOKS BY JEFFREY BROWN

From Chronicle (WWW.CHRONICLEBOOKS.COM): Cat Getting Out Of A Bag Cats Are Weird Vader's Little Princess